FLORAL
DESIGNS
COLORING BOOK

JESSICA MAZURKIEWICZ

DOVER PUBLICATIONS, INC.
MINEOLA, NEW YORK

NOTE

This elegant coloring collection features beautiful bouquets of daisies, lilies, hydrangeas, zinnias, roses, and more. The flowers are arranged in interlocking and overlapping patterns, and enclosed in borders of petals or leaves for a finished look. Plus, perforated pages make displaying your work easy!

Bibliographical Note

Floral Designs Coloring Book is a new work, first published
by Dover Publications, Inc., in 2012.

International Standard Book Number

ISBN-13: 978-0-486-47245-4
ISBN-10: 0-486-47245-0

Manufactured in the United States by RR Donnelley
47245015 2015
www.doverpublications.com

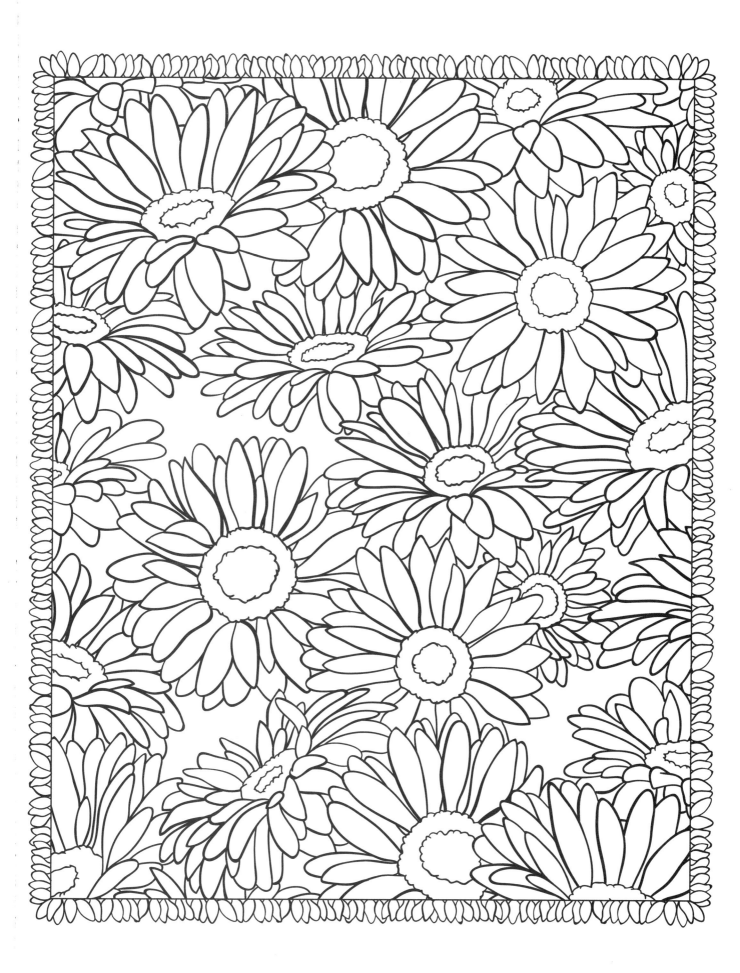

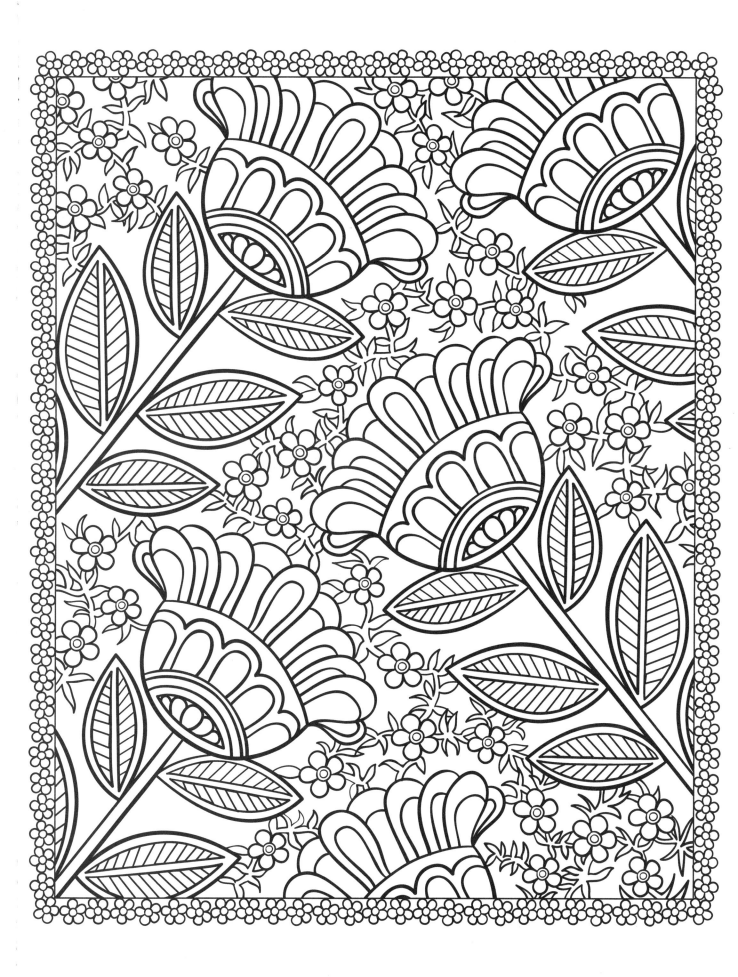

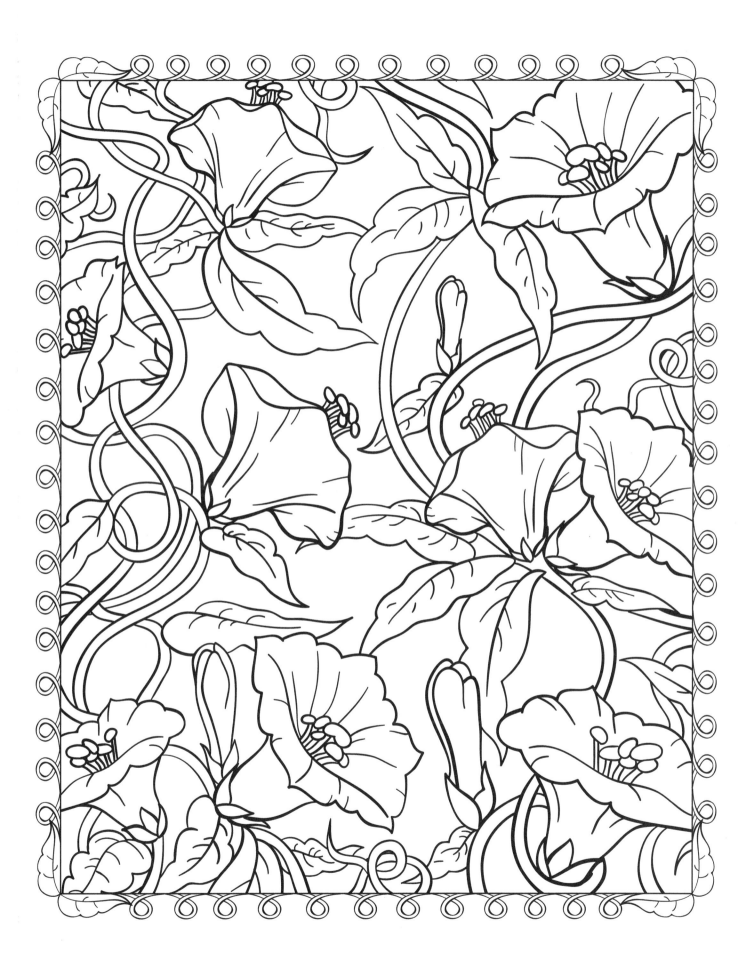

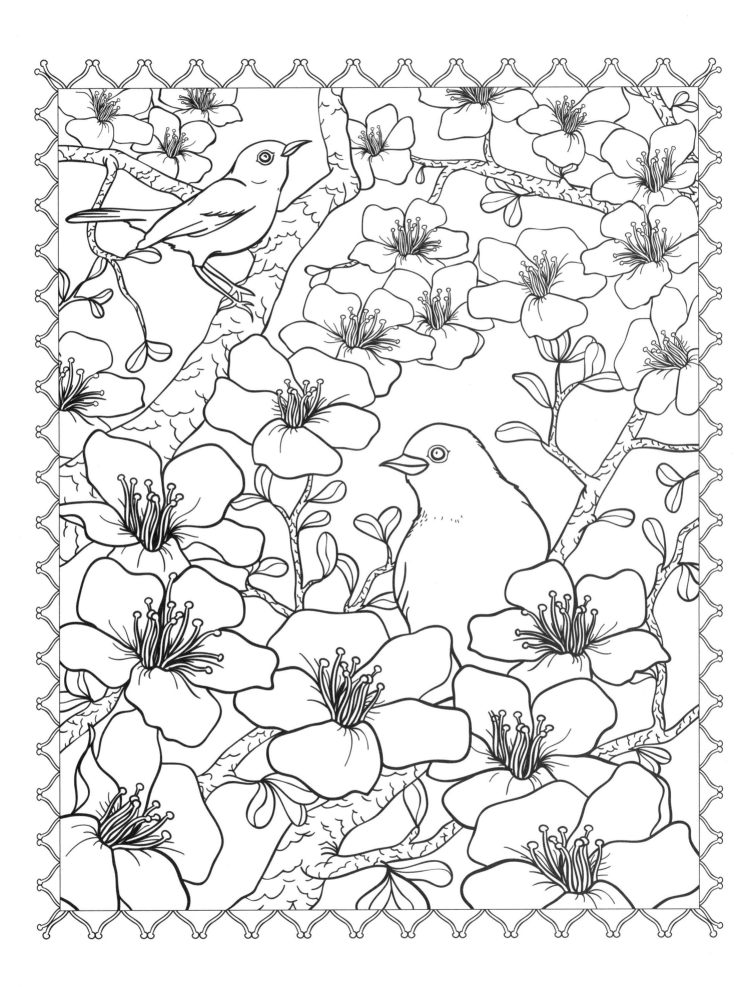

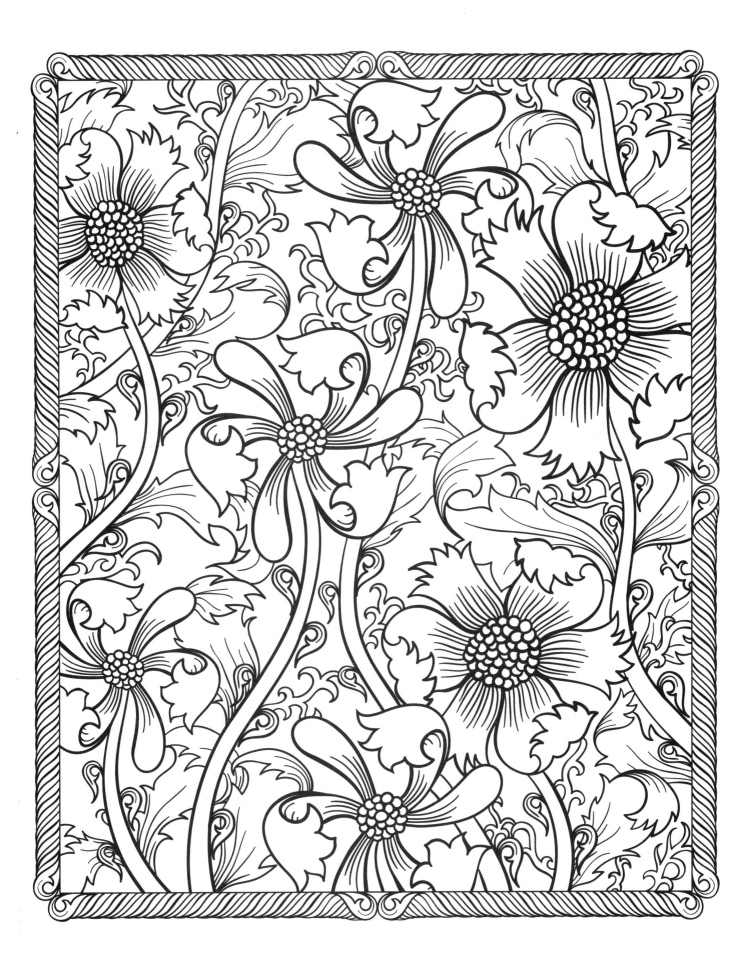

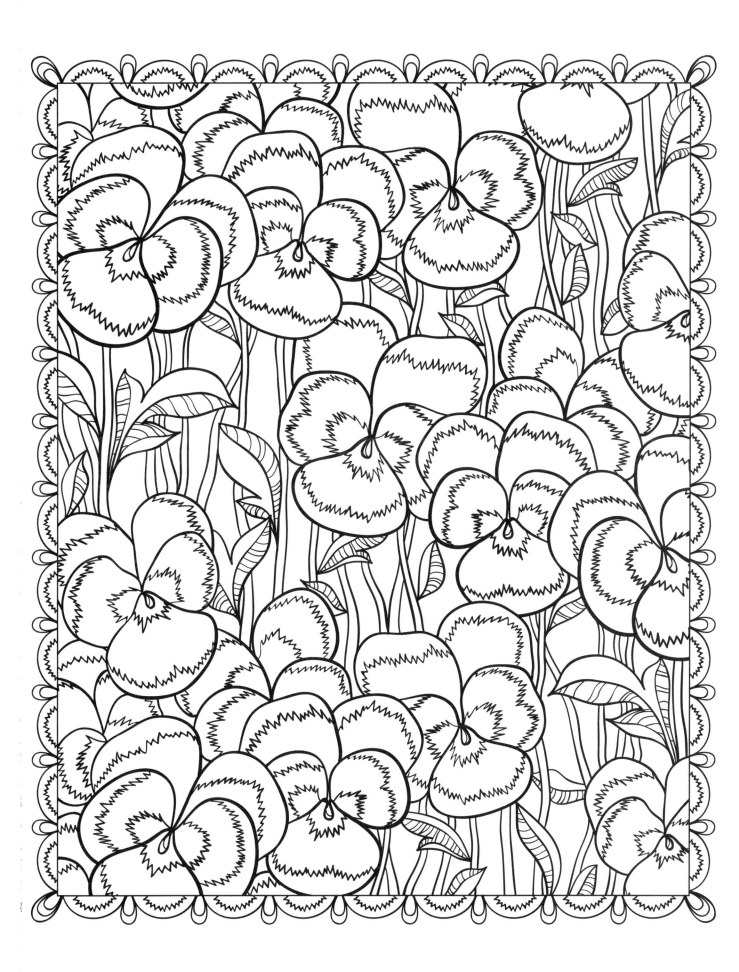

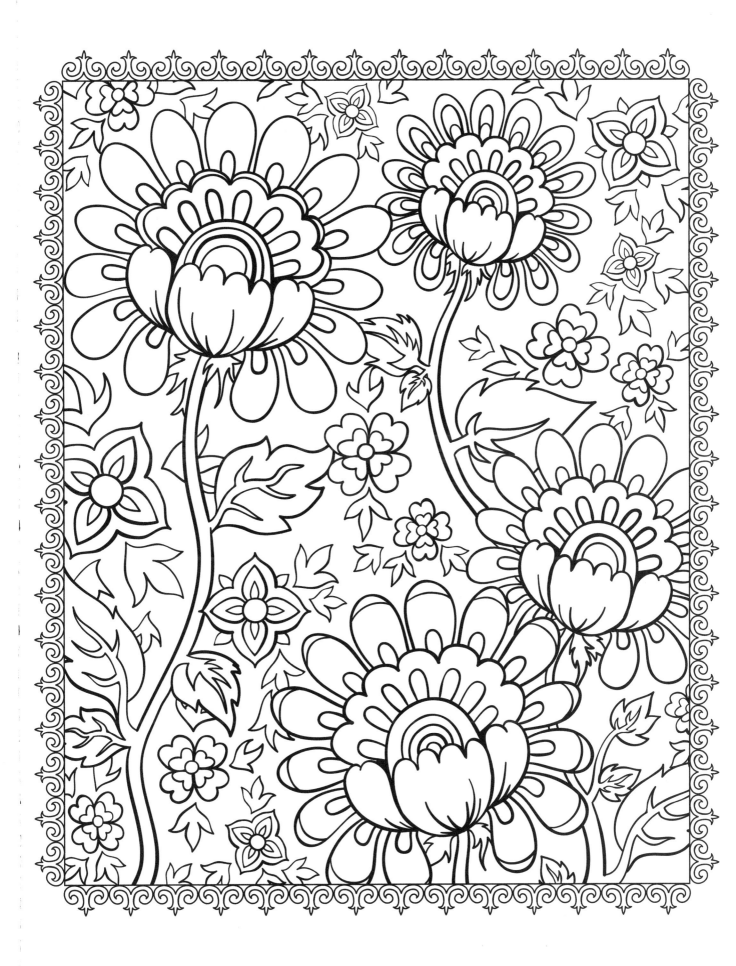

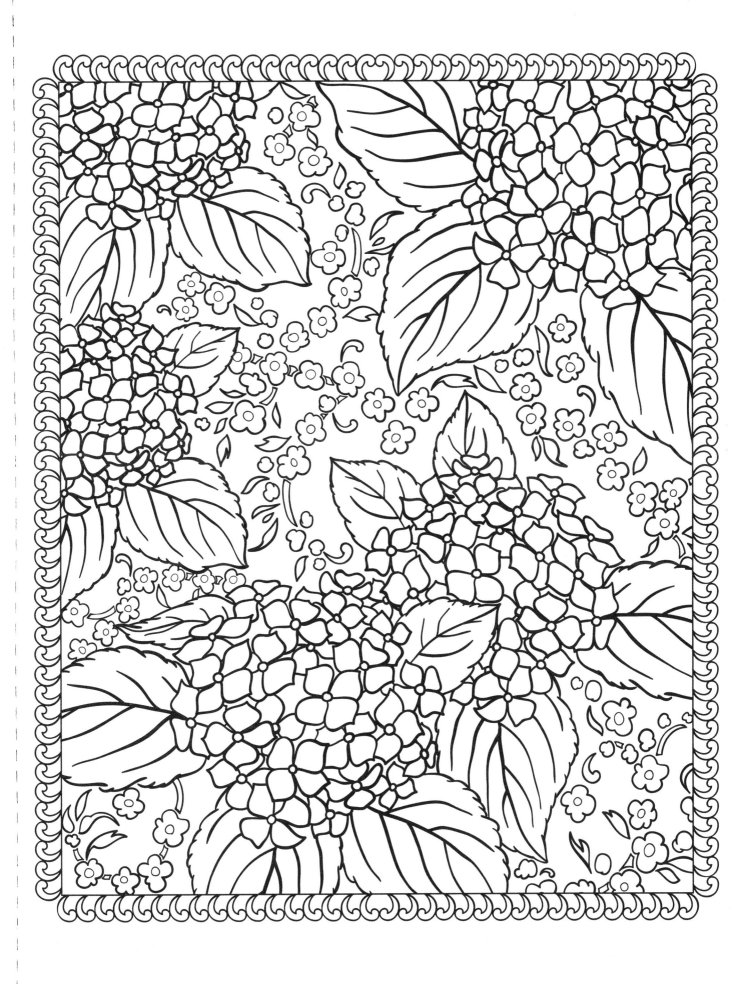

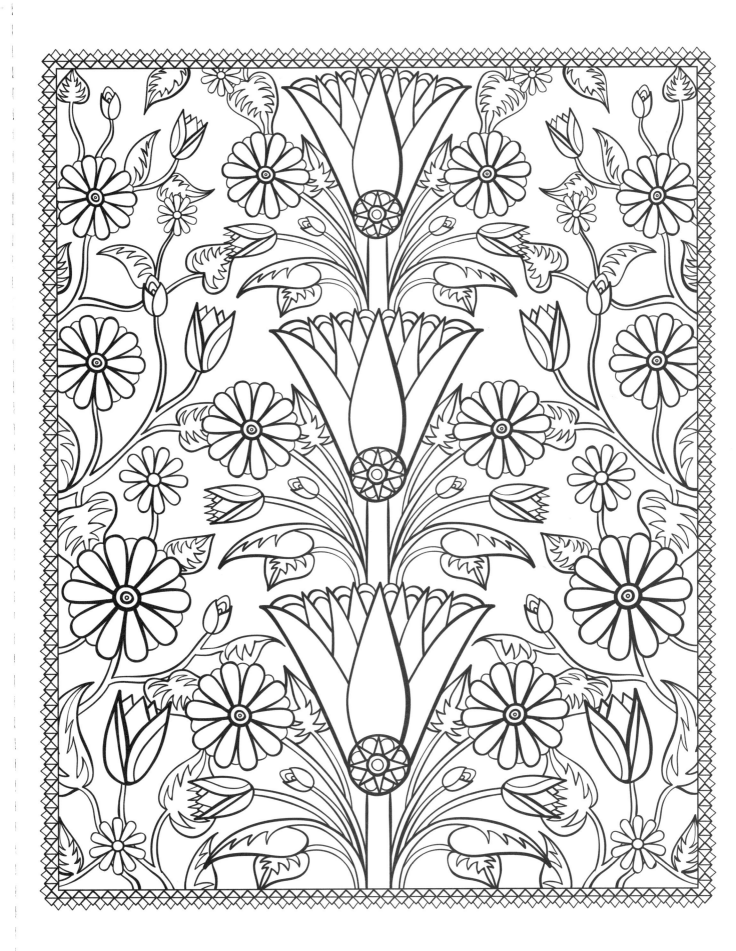

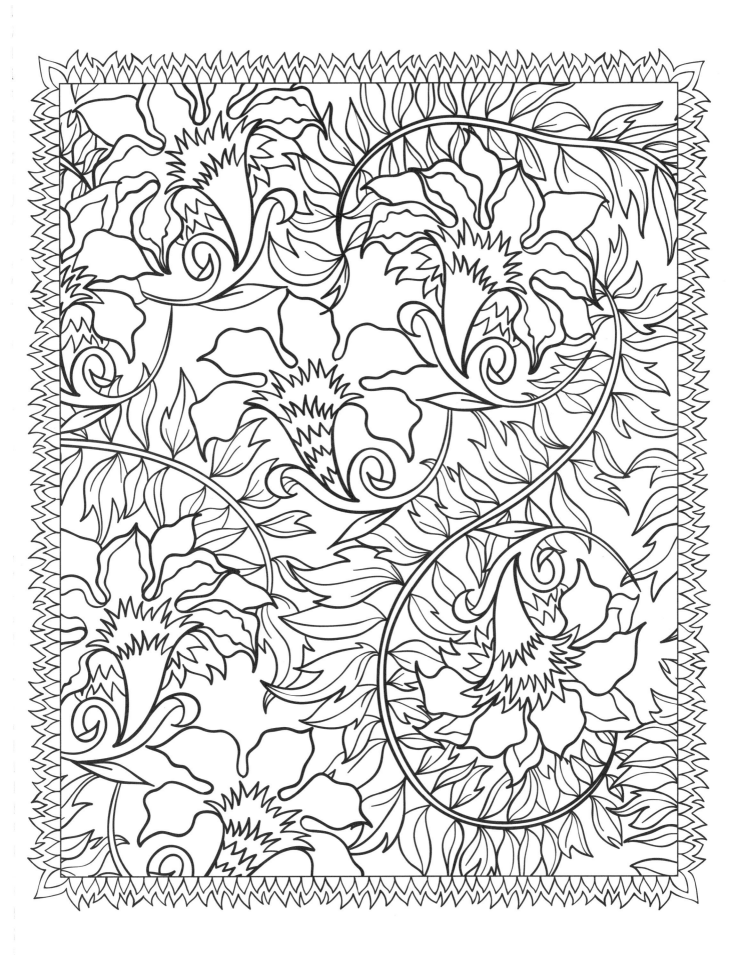

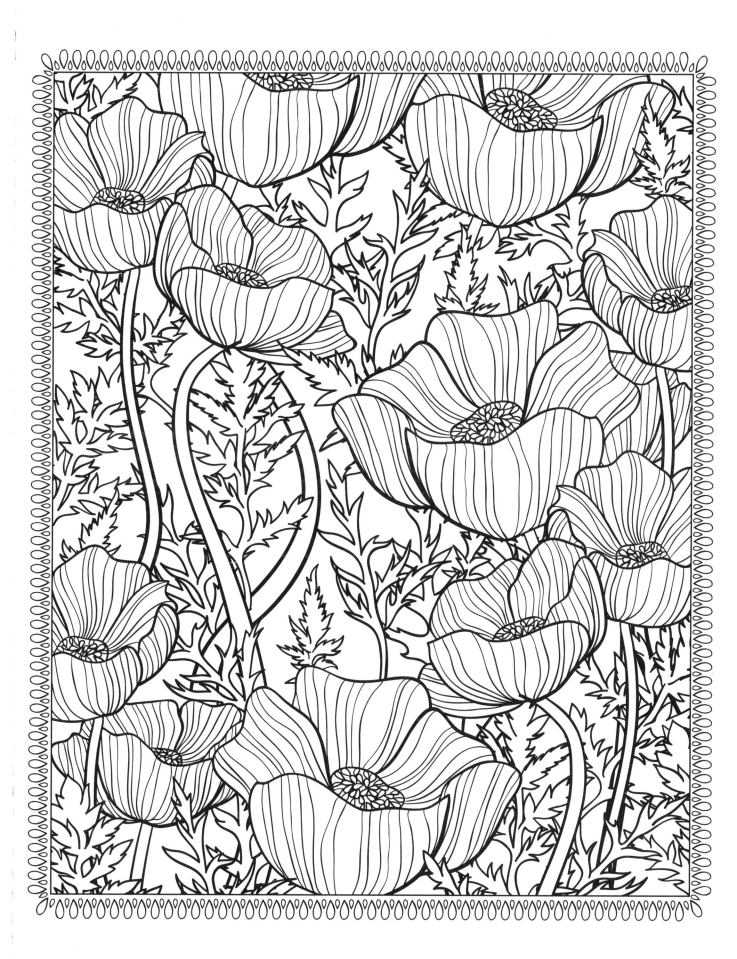

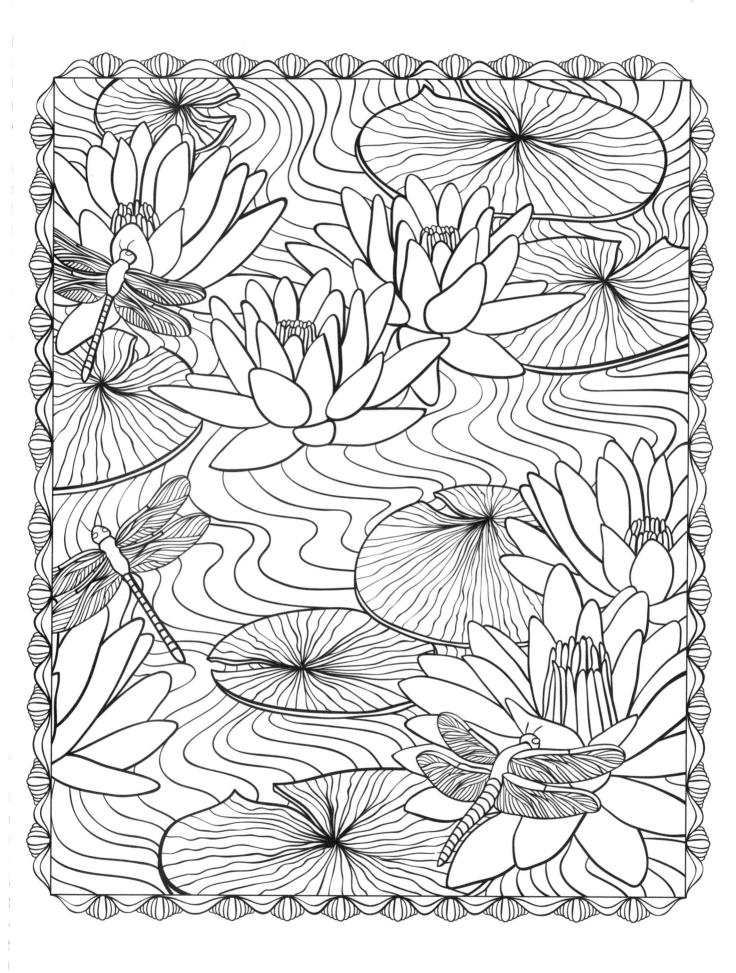

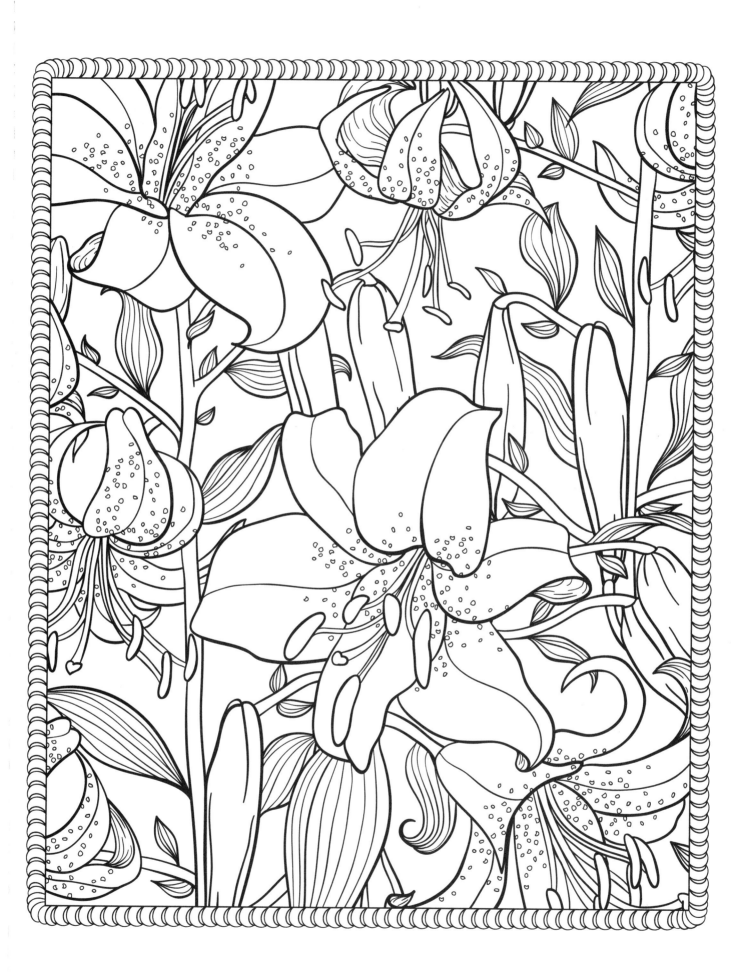

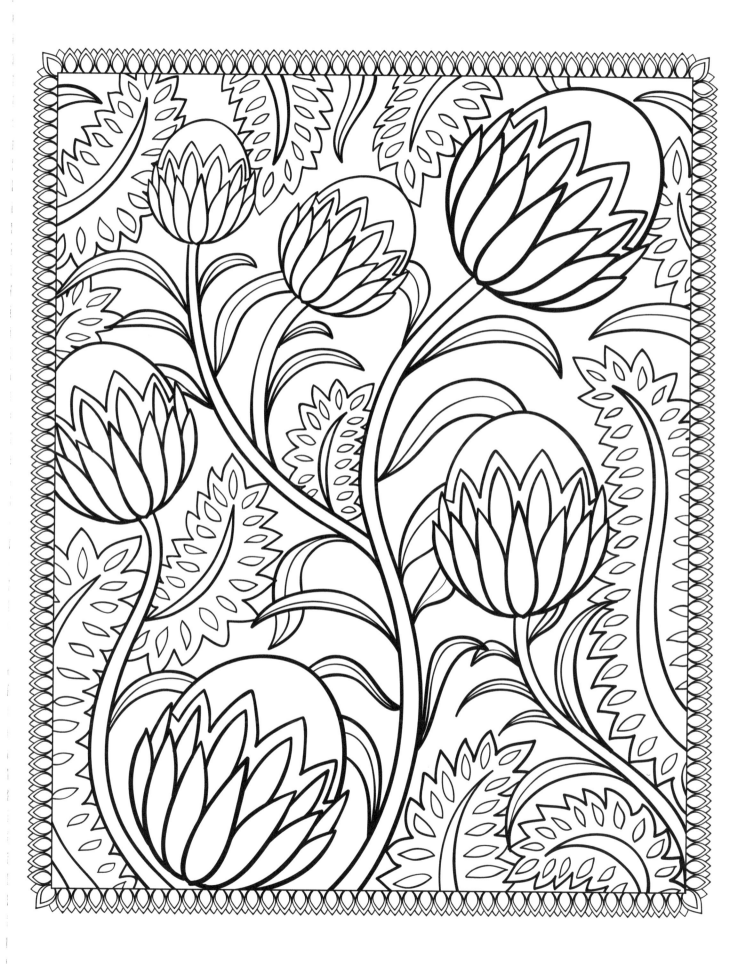

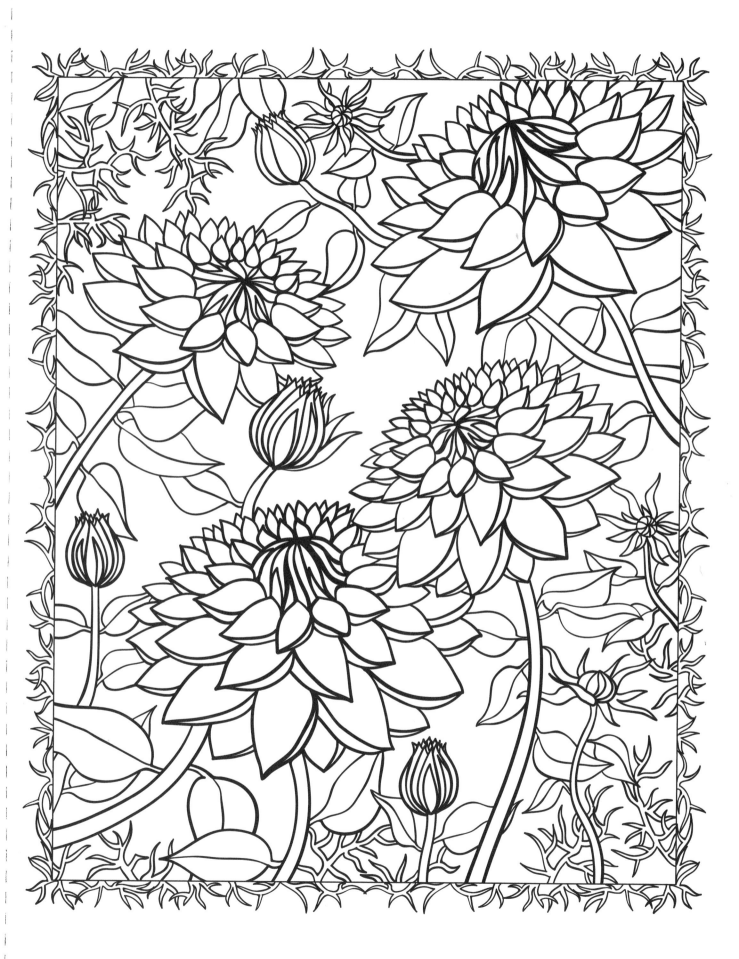

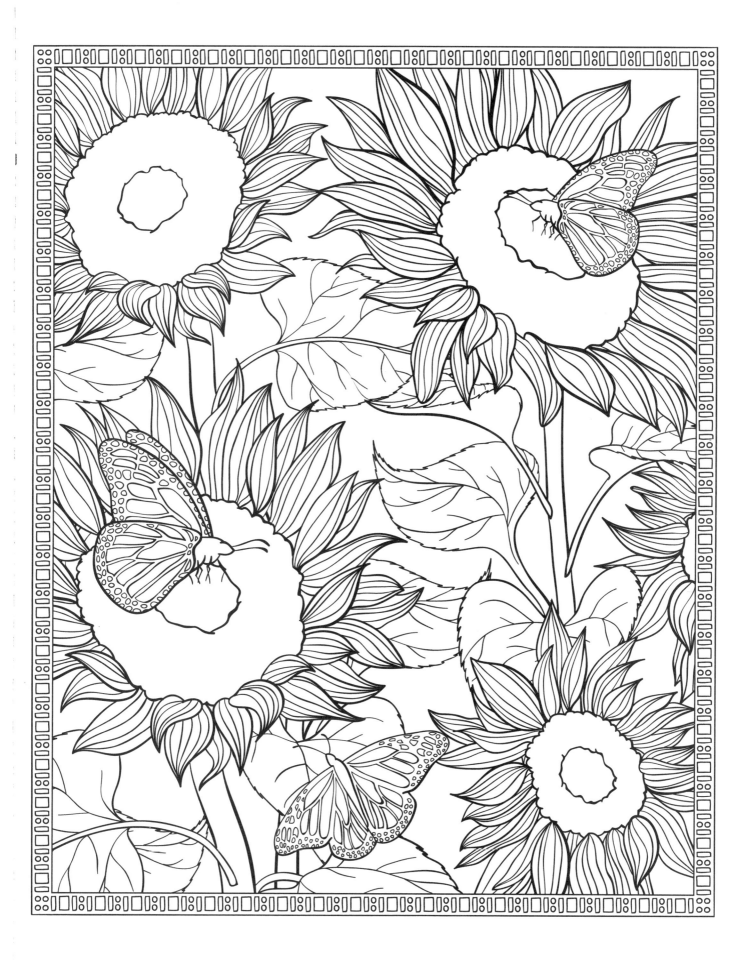

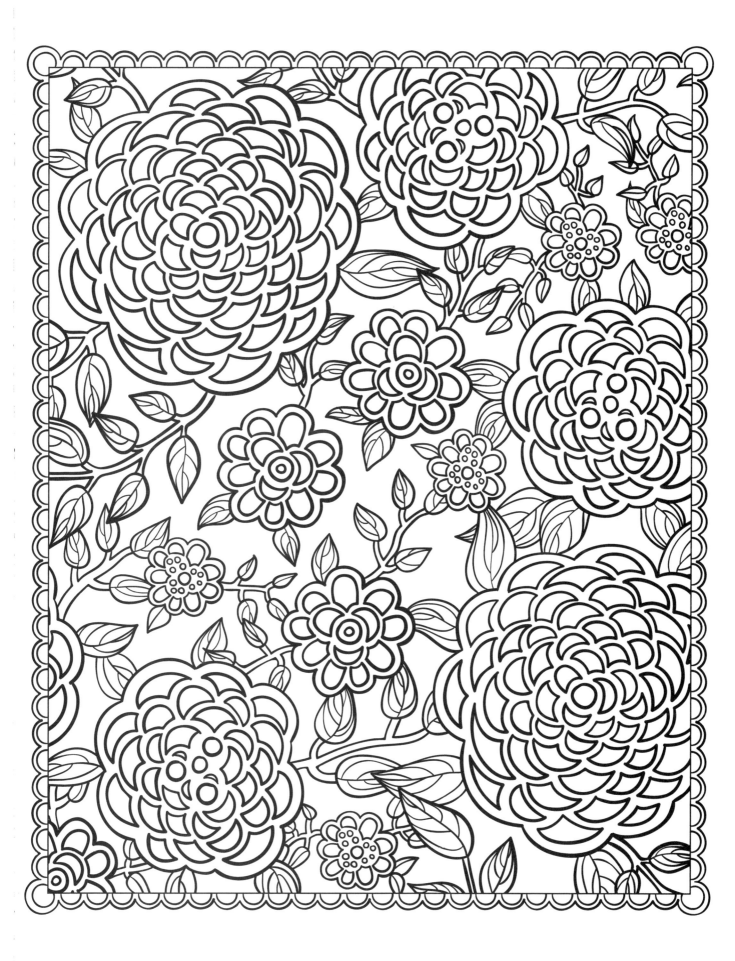

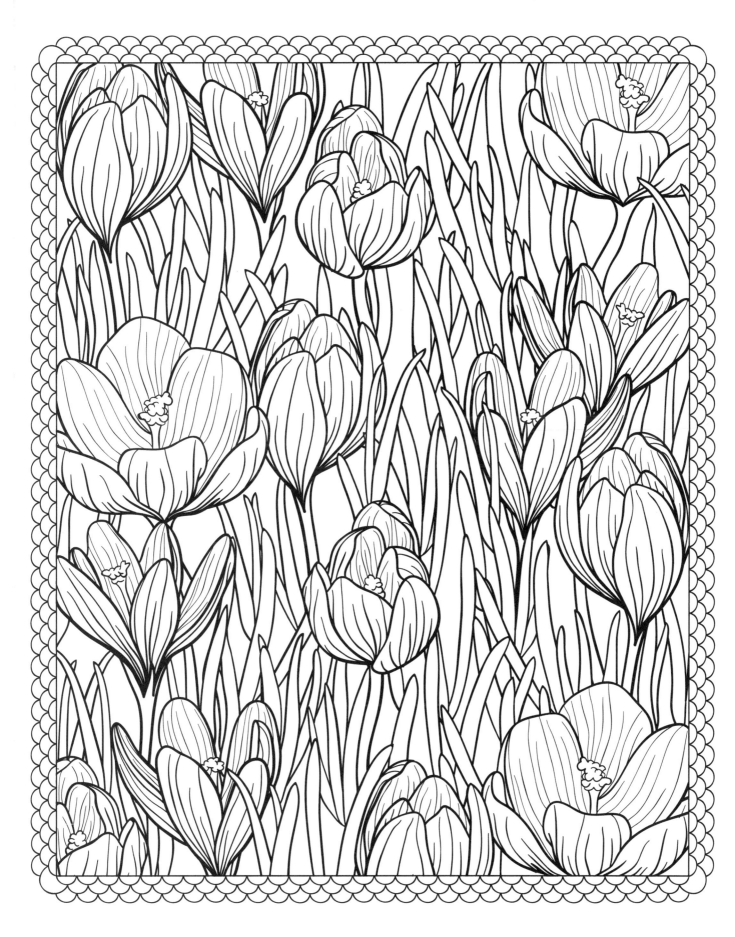

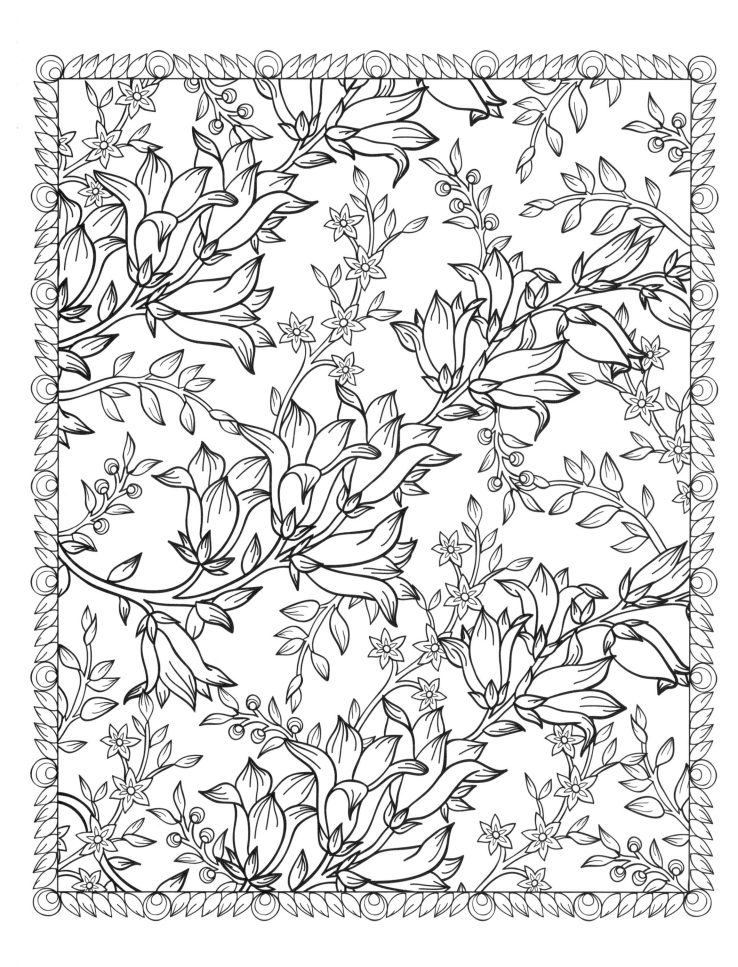

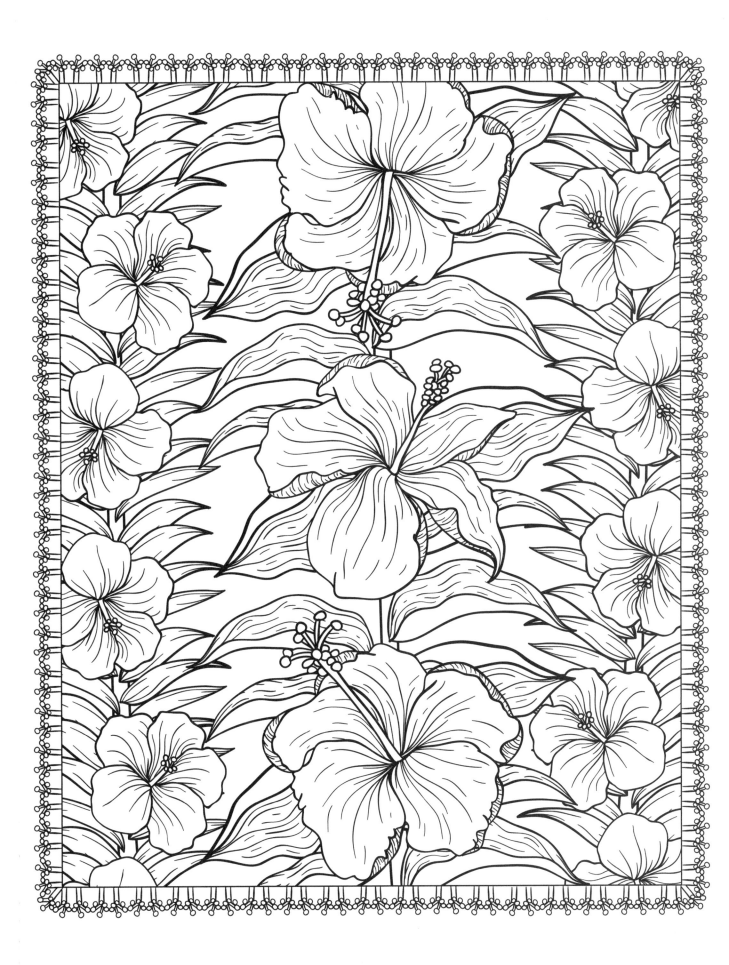

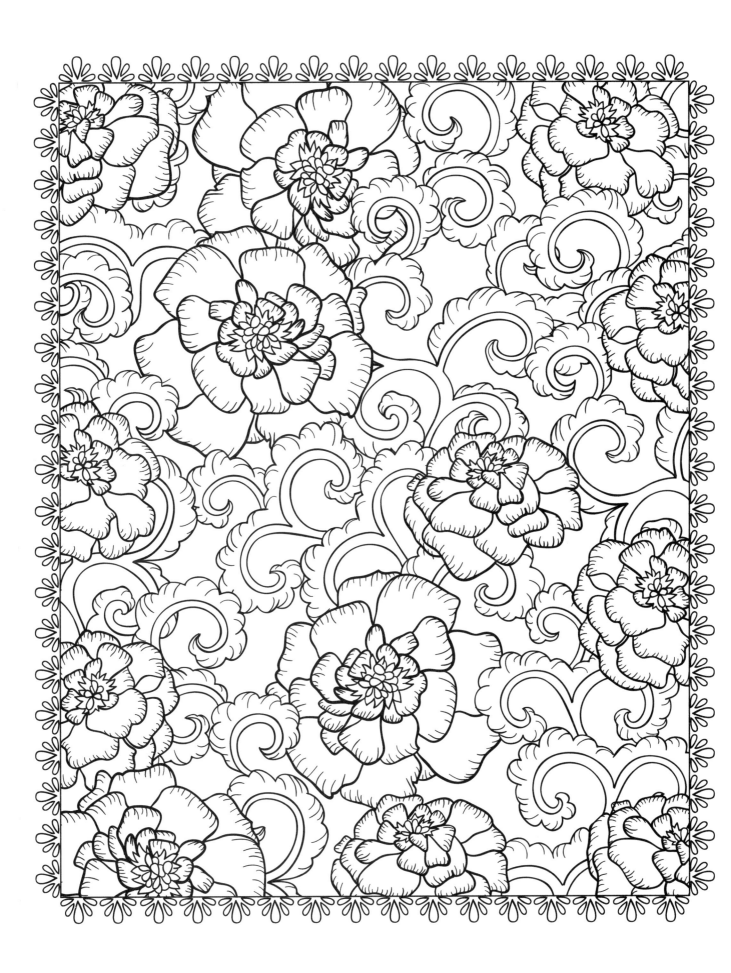

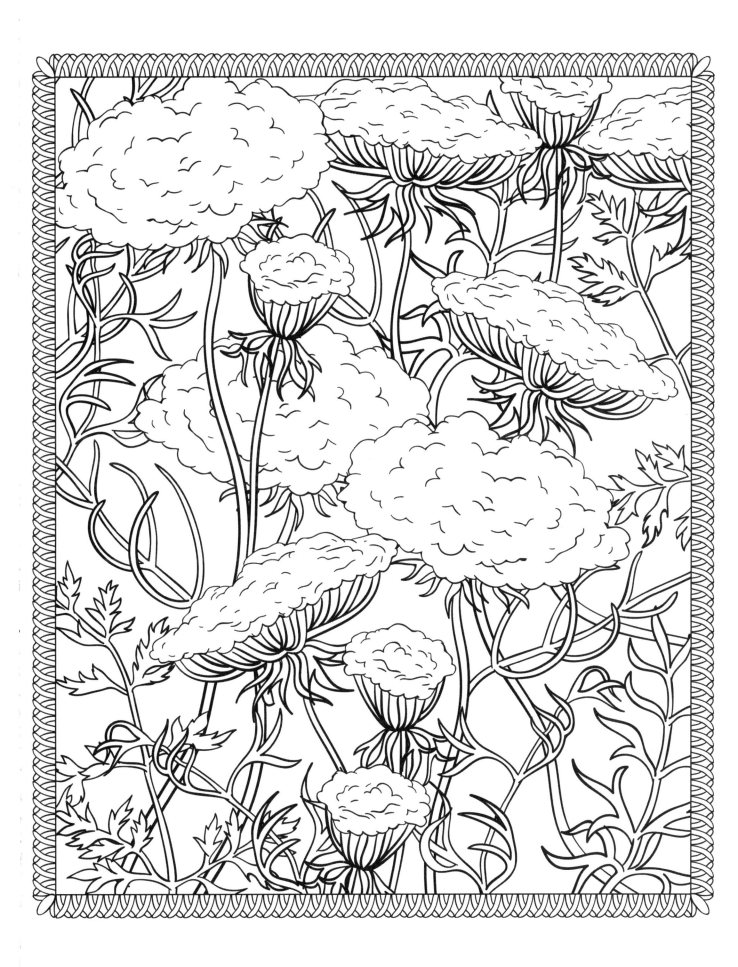

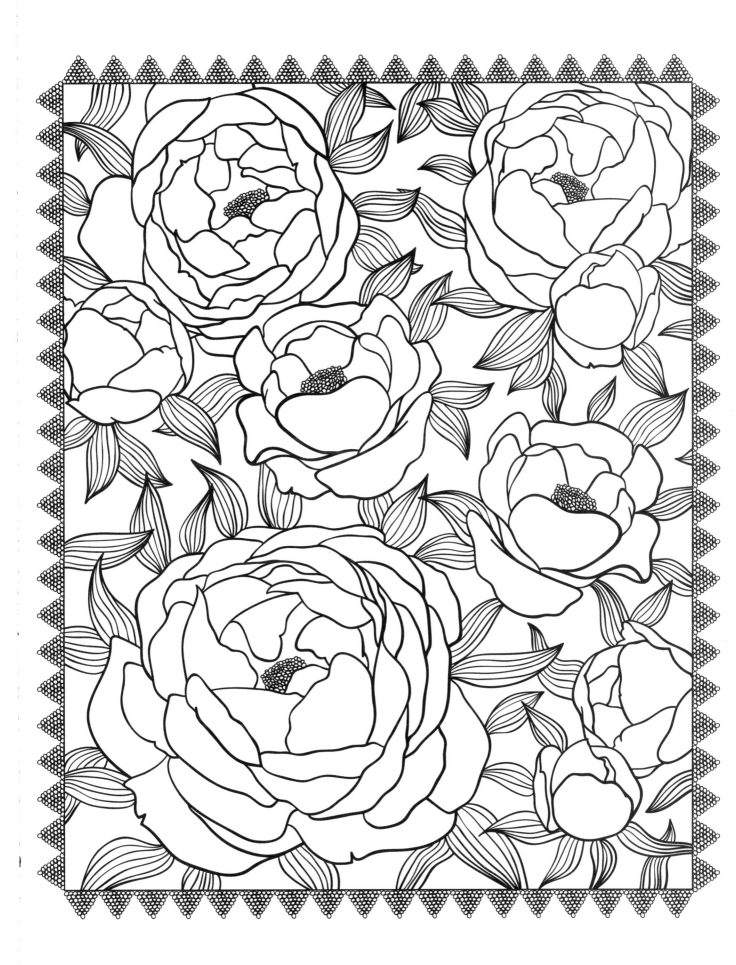

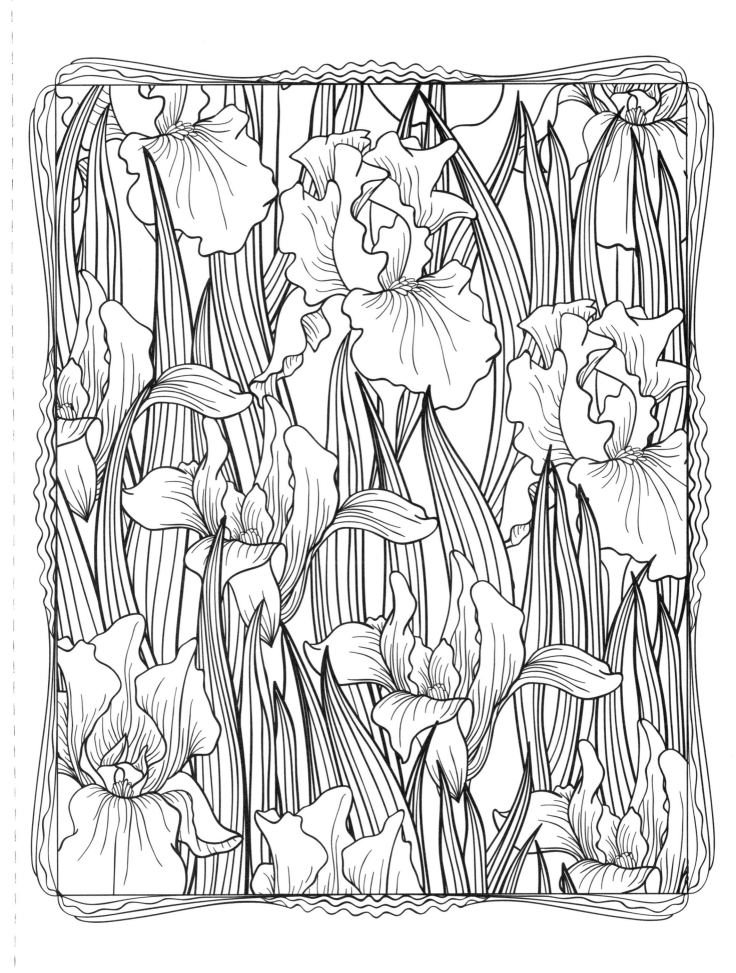

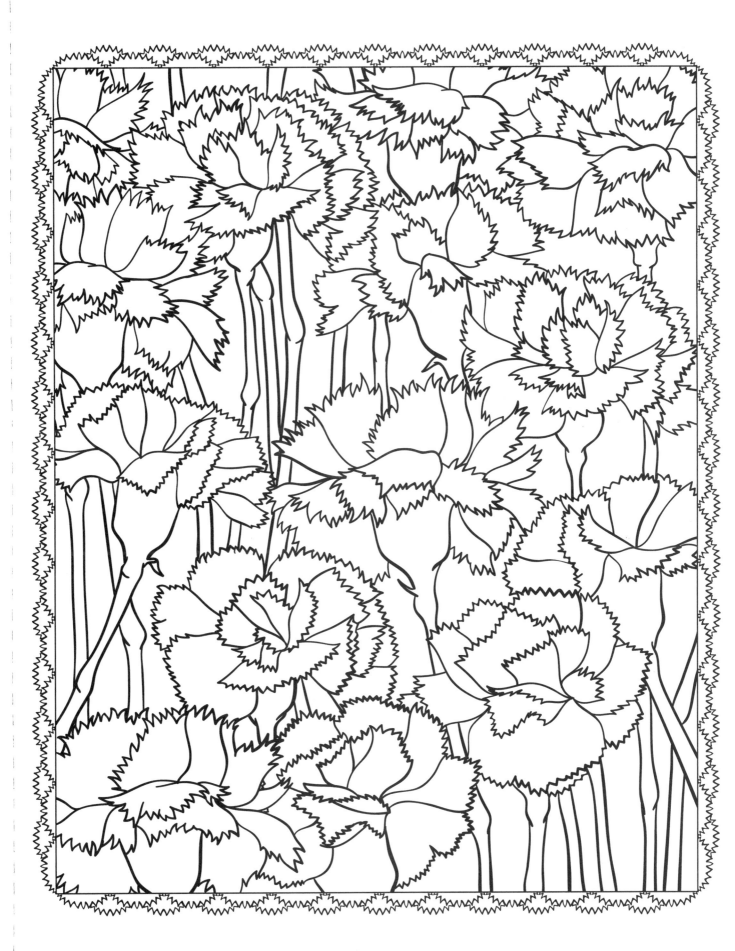

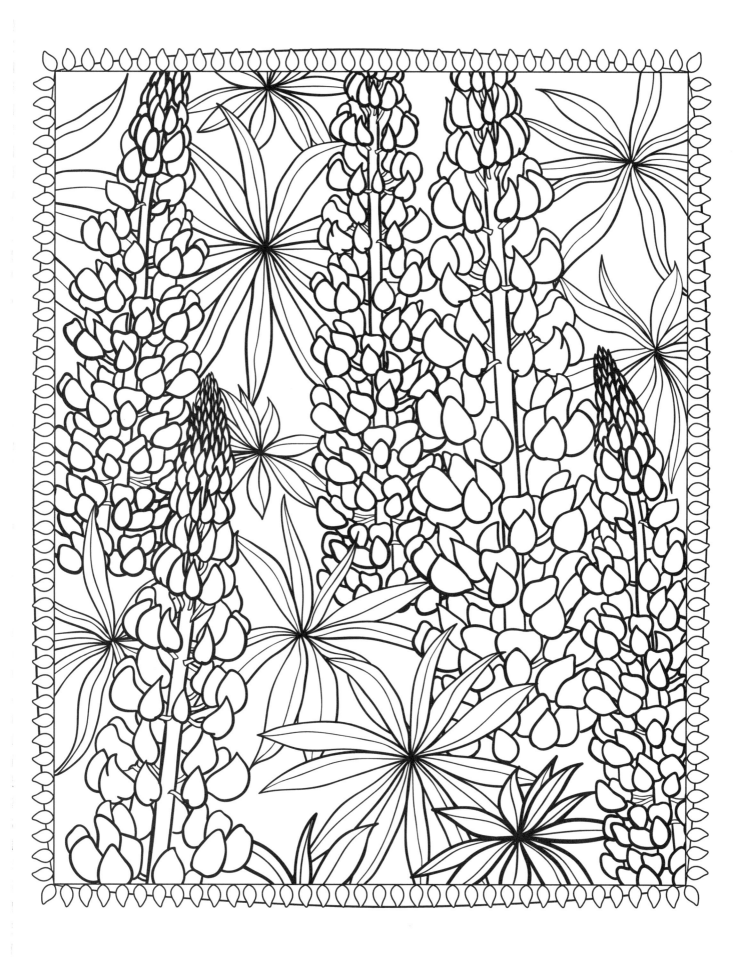

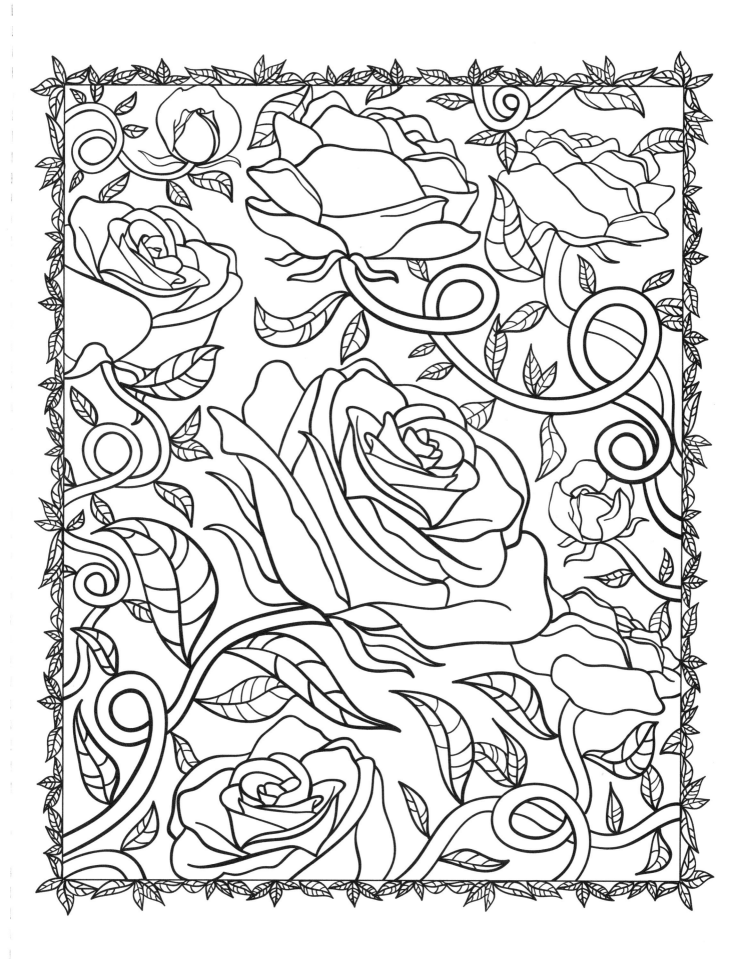

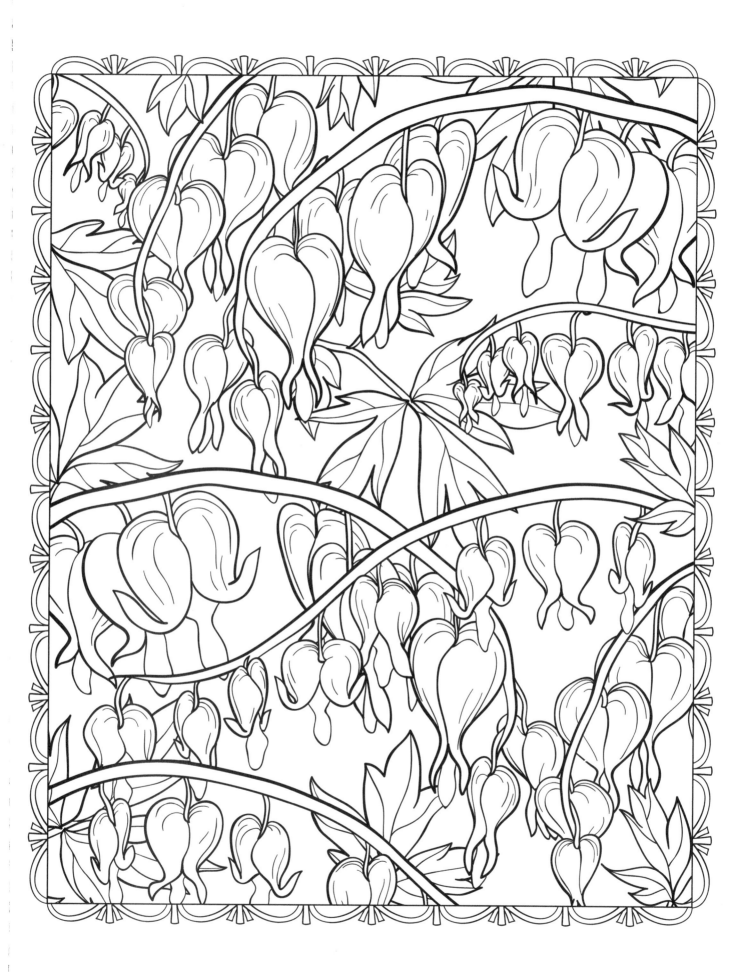

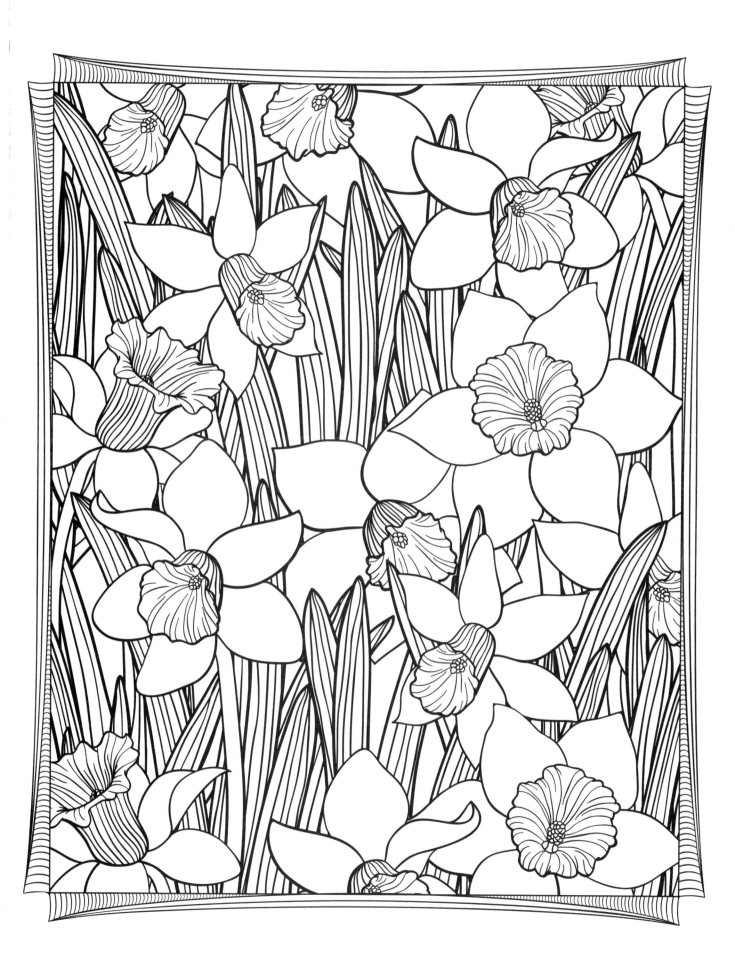

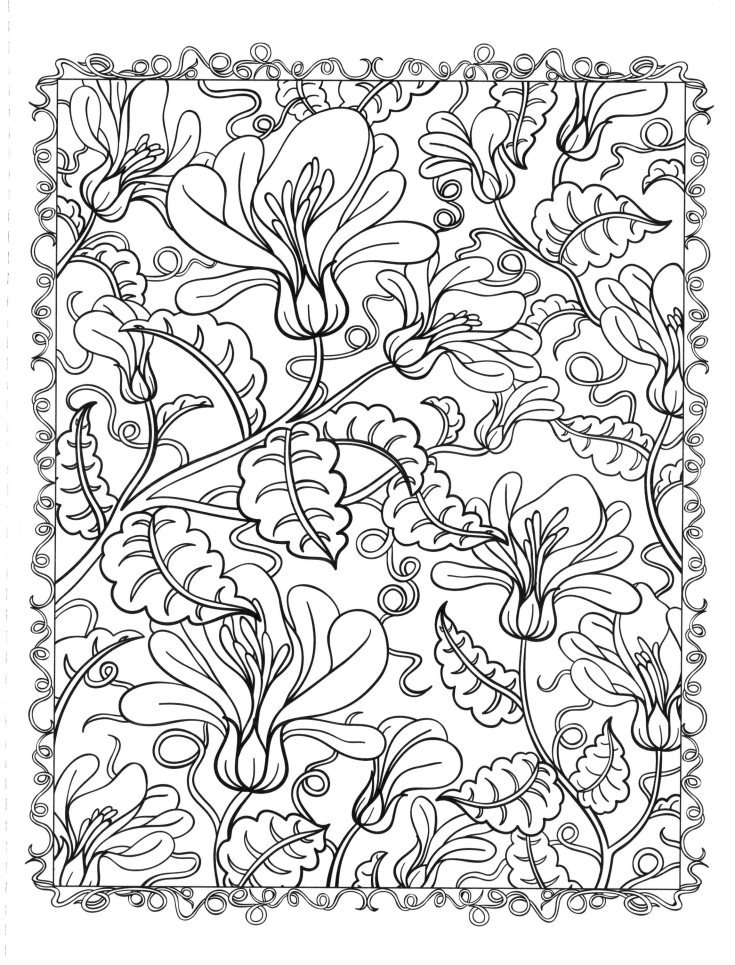

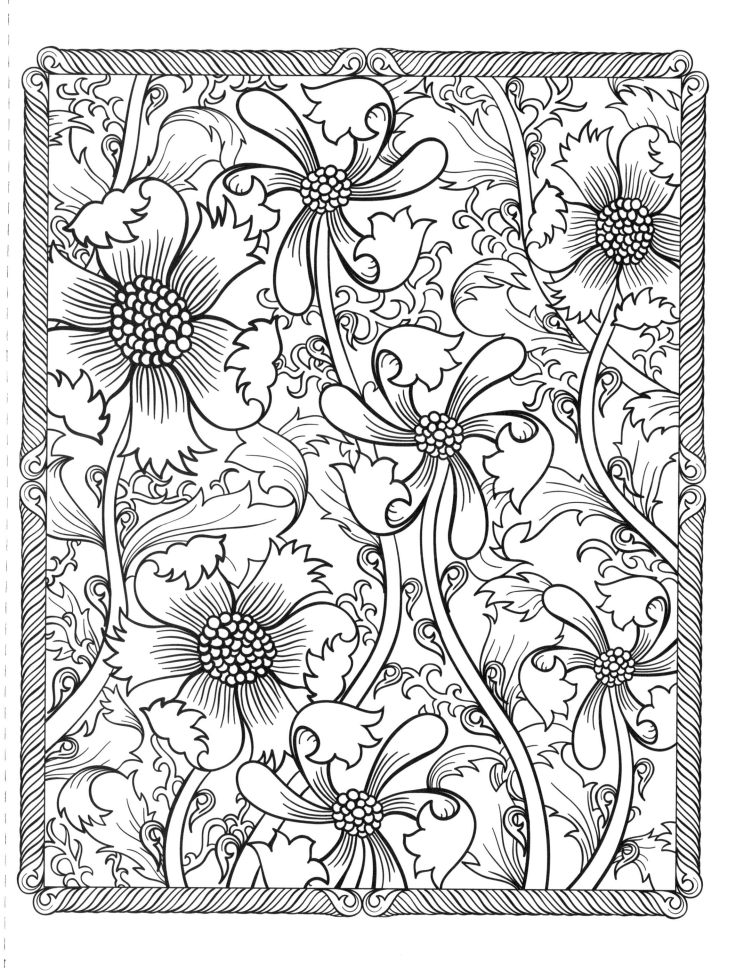